picturing MODERNITY

For Jona and Adam.
Ma̅d... darkroom
... Meghan

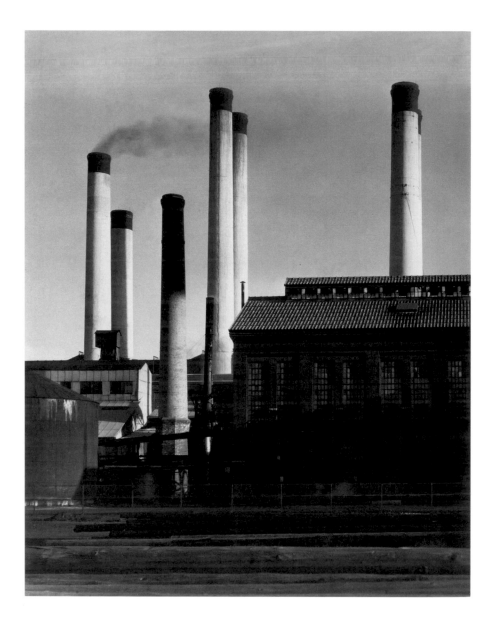

PICTURING

Modernity

Highlights from the
Photography Collection
of the San Francisco
Museum of Modern Art

SAN FRANCISCO MUSEUM OF MODERN ART

LIBRARY OF CONGRESS
CATALOGING-IN-PUBLICATION DATA

Nickel, Douglas R. (Douglas Robert), 1961–
Picturing Modernity: highlights from the photography collection of the San Francisco Museum of Modern Art/Douglas R. Nickel.
 p. cm.
ISBN 0-918471-46-X (pbk.)
1. San Francisco Museum of Modern Art—Photograph collections—Catalogues.
2. Photograph collections—California—San Francisco—Catalogues. 3. Photography, Artistic—Catalogues. I. San Francisco Museum of Modern Art. II. Title.
TR6.U62S264 1998
779'.074794'61—dc21 98-15253
 CIP

Publication Manager: Kara Kirk
Editor: Fronia W. Simpson
Designer: Catherine Mills
Publication Assistants: Alexandra Chappell and Sarah Borruso
Duotone separations: Robert Hennessey
Printed and bound in Italy

Cover: Alexander Rodchenko, *Fire Escape*, from the series *House on Myasnicka Street*, 1925 (pl. 40)

Frontispiece: Charles Sheeler (American, 1883–1965), Untitled (Electric Power Plant, New Bedford, Massachusetts), ca. 1938. Gelatin silver print, 9 9/16 x 7 7/16 in. (24.3 x 18.9 cm). Gift of Anne MacDonald Walker in honor of Samuel Wagstaff, 86.117

CONTENTS

This foreword is my first for a San Francisco Museum of Modern Art publication, having only assumed my position as the Museum's sixth director earlier this year. Nonetheless, I already feel a deep kinship with the collection of photography highlighted in these pages, as well as with the six-decade program that it represents. As a long-time admirer of SFMOMA's program in photography, I am delighted to be assuming leadership of an institution that has made understanding the medium such a central part of its mission. Indeed, one of my strongest beliefs—and one of the central challenges of SFMOMA in particular and modern art museums in general—is to explore what it means to be a museum of the modern, to "picture modernity" and the visual culture of our time. SFMOMA has grappled with this question since its founding years, and its passionate commitment to photography is vital evidence that this museum has long embraced, championed, and interrogated the notion of the modern.

The following pages illustrating outstanding works in SFMOMA's collection not only trace essential moments of photographic history but also reveal an incredibly rich aspect of this museum's history. As Douglas Nickel, the Museum's associate curator of photography, makes clear in his introductory essay, it is a history of people—of photographers who led this community in their artistic expression and in their advocacy for photography's place within museums; of benefactors who supported the burgeoning medium and gave generously to maintain its legacy; and of curators who each contributed his or her own distinctive interests and direction to the development of our holdings.

The creation of this publication—which has long been in demand by visitors eager to have documentation of the collection—is the result of the combined efforts of many departments at the Museum. The Department of Publications and Graphic Design was instrumental in making this volume a reality. I would especially like to thank Sarah Borruso, editorial coordinator; Alexandra Chappell, publications assistant; Kara Kirk, director of publications and graphic design; and Terril Neely, senior graphic designer, for their enthusiasm and commitment to *Picturing Modernity*. We are equally grateful to

8

Fronia W. Simpson, who undertook the important task of editing the publication's man-
uscript. Catherine Mills, former SFMOMA director of graphic design and publications,
conceived the very elegant design of this book. She was assisted in this endeavor by
David Betz, and we thank them both for the great skill and sensitivity they brought to
the project.

Other members of the SFMOMA staff provided invaluable assistance in research-
ing and supporting every phase of this publication's creation. Particular thanks are due to
Dr. Sandra S. Phillips, curator of photography, and Dr. Nickel, who oversaw the selec-
tion of works in the publication and who direct the superior collecting and exhibition
activities in photography that continue our distinguished tradition. In addition, I would
like to recognize the contributions of Lori Fogarty, deputy director for curatorial affairs;
Stuart Hata, associate director of retail and wholesale operations; Ariadne Rosas, sec-
retary, Department of Photography; Thom Sempere, graphic study manager; Jennifer
Small, assistant registrar, rights and reproductions; Melanie Ventilla, curatorial assistant;
and Irma Zigas, director of retail and wholesale operations.

Finally, I would like to acknowledge the generosity of the numerous bene-
factors this museum has had over the years: those who have contributed the works
of art that have enriched the Museum's collection and make it one of the most out-
standing in the world, and the many others who have supported the exhibitions and
programs organized by the Department of Photography from which a majority of
these acquisitions are drawn. Special acknowledgment is due to the Department's
auxiliary support organization, Foto Forum, and to the members of the Photography
Accessions Committee, who have worked closely with the curators in recent years
to expand and refine SFMOMA's holdings. I also wish to thank the past directors of this
museum, beginning with Grace L. McCann Morley, who had the foresight to initiate
a photography collection in San Francisco—one of the first museums in this country
to integrate photography into its curatorial program—and extending to my immediate
predecessor, John R. Lane, who oversaw the construction of our new building, which
includes a permanent space for the exhibition of these great treasures.

David A. Ross

PICTURING MODERNITY

DOUGLAS R. NICKEL

Though the invention of photography dates back to the 1830s, it was not until the first decades of the twentieth century that the medium assumed the status of an art form deemed worthy of collection and exhibition by museums, and even then by only a handful of institutions. The San Francisco Museum of Modern Art (SFMOMA) was among these forerunners. Thanks to prescient leadership, enlightened early benefactors, and good fortune, this was one of the first museums in the world to understand and present photography as one among several of the fine arts.

Under the initial guidance of its first director, Grace L. McCann Morley, the San Francisco Museum of Art (as it was called originally) was distinguished by a daring and ambitious artistic program, which included the first solo museum exhibitions anywhere for Jackson Pollock, Mark Rothko, Arshile Gorky, Robert Motherwell, and Clyfford Still. Moreover, the San Francisco Museum of Art recognized photography as one of the most vital, expressive art forms to emerge in the modern period, and from the moment of its opening in 1935, Morley decided that collecting, exhibiting, and interpreting modern photographs would be part of its cultural mandate. As farsighted as this decision seems in retrospect, it was also eminently sensible, for in the 1930s Northern California happened to be home to a community of progressive photographers destined to write their own important chapter in the history of the medium.

The f.64 Group, named for the sharpest setting on a view camera's lens, came into being in 1932 with a group exhibition at San Francisco's M. H. de Young Memorial Museum. Members Ansel Adams, Imogen Cunningham, Willard Van Dyke, John Paul Edwards, Sonya Noskowiak, Henry Swift, and Edward Weston drafted a statement to accompany the show, declaring their allegiance to a style of photography that was clear, precise, premeditated, and without affectation. These talented people not only produced serious and spirited photographs but went one better, articulating a distinctive ideological position. In addition, the forceful personalities of Adams and Weston effectively made San Francisco the most important American

center for photography outside New York. By 1935 Weston was recognized internationally as second only to Alfred Stieglitz in the leadership of America's creative photographers (he organized, for example, the West Coast contribution to the 1929 *Film und Foto* exhibition in Stuttgart), and the somewhat younger Adams saw himself as Stieglitz's heir apparent, opening a gallery in San Francisco fashioned after Stieglitz's in New York and becoming an important voice in the creation of a photography department at New York's Museum of Modern Art in the late 1930s.

The f.64 exhibition had made San Francisco a world center for modern photographic theory and practice, so it is not altogether surprising that photography began to be collected and exhibited at San Francisco's new modern art museum the first year of its existence. Peter Stackpole, son of the sculptor Ralph Stackpole, used the recently introduced 35mm camera to take a breathtaking series of views showing the stylish Bay Bridge under construction across San Francisco Bay; these photographs were exhibited at the Museum in 1935, where they were applauded by Adams and his f.64 colleagues. Adams's own close-up portrait of the Mexican painter José Clemente Orozco (plate 46) was one of the first photographs to enter the permanent collection, part of a group given in 1935 by the Museum's most important early benefactor, Albert Bender. The intense Orozco, a member of the avant-garde muralist movement sweeping America, had been framed by Adams's modernist lens only two years earlier.

Bender was an insurance broker in San Francisco, a man with a passionate interest in modern art and an almost unlimited capacity for philanthropy. He underwrote the cost of publishing Adams's first portfolio of photographs and purchased works from all the leading f.64 members. When he donated the bulk of his personal collection to SFMOMA in 1939, the Museum acquired the best representation of contemporary West Coast photography then in existence, and the bequest that followed Bender's death two years later supplemented his original gift with twenty-six works, including those of local photographers Imogen Cunningham and Dorothea Lange. By the beginning of World War II, SFMOMA already boasted photography holdings of some stature and a program that had photographic exhibitions regularly appearing in its galleries.

The Museum experienced something of a hiatus during the war, when its building was called into service for the inauguration of the United Nations. In the immediate postwar period, the photography program was resumed with particular

zeal by curator John Humphrey, who more than any other individual shaped the constitution of the collection in its first forty years. It was Humphrey, working in coordination with Morley, who oversaw the most significant additions through purchase and gifts, such as the arrival in 1952 of a magnificent group of sixty-seven Stieglitz photographs. On Adams's recommendation, Stieglitz's widow—the painter Georgia O'Keeffe—offered a donation of forty-two works if the Museum would purchase twenty-five others at one hundred dollars each (plates 16, 20, and 30). Morley managed to raise the necessary funds, and Humphrey soon after arranged an exhibition of the photographs in San Francisco. The present-day value of such a select group from Stieglitz's own collection is inestimable, and its arrival broadened the scope of SFMOMA's collection to a truly national level.

Until the boom in the photography market in the early 1970s, the Museum's collecting (like that of her peer institutions) was largely circumstantial. Humphrey was kept busy with a formidable schedule of exhibitions but continued to mastermind the acquisition of important groups of photographs that augmented the collection in material ways. For example, thirty Edward Weston photographs were purchased from the artist's son Brett in 1962, and the following year Humphrey accepted the Henry Swift collection from Swift's widow, Florence. A stockbroker by trade and one of the founding f.64 Group members, Swift had shown his photographs in the 1932 de Young exhibition and had acquired consummate examples of work by Adams, Cunningham, Van Dyke, and Weston during his association with them in the 1930s. Florence Swift, working with a young photographer named Don Ross, supplemented this core group with additional works donated by Adams, Cunningham, and Brett Weston (e.g., plate 21), in memory of their onetime colleague. Similarly, Humphrey made contact with the former Farm Security Administration photographer Theo Jung about this same time. In 1964 Jung donated a group of twenty-three photographs by fellow FSA workers Jack Delano, Walker Evans, Dorothea Lange, Russell Lee, and Arthur Rothstein, hence forming the basis for the Museum's future strength in the area of documentary photography. This group attracted other donations, such as the fifteen images by the FSA photographer Marion Post Wolcott given by Arthur Rothstein in 1977. When the local photographer, critic, and teacher Margery Mann died the same year, her personal collection of over one hundred contemporary photographs—which included works by Diane Arbus (plate 54), among others—was gratefully accepted by Humphrey.

Thus, when photography became a subject of more general critical regard in the early 1970s, the San Francisco Museum of Art was already a commanding presence in the photographic world, and its broad exhibitions and collecting programs conferred on it international prominence. In 1974 Henry T. Hopkins was named director of the Museum and brought with him a determination to make SFMOMA the premier West Coast showcase for twentieth-century art. (The name change to San Francisco Museum of *Modern* Art the next year reflected this more focused identity.) John Humphrey retired in 1978 and was replaced by Van Deren Coke, former head of the George Eastman House in Rochester. With Coke as curator, the Museum formally established a distinct Department of Photography in 1980, and an unprecedented level of activity issued forth in the next seven years.

Under Coke, fully one-third of the Museum's exhibitions activity was devoted to photography, in both its historical and contemporary manifestations. Coke's landmark *Avant-Garde Photography in Germany, 1919–1939* presentation in 1980 signaled his interest in a rich but overlooked episode in photographic history; the exhibition circulated throughout the United States and Europe over the next two years, and its catalogue quickly became a standard reference. This concern for the interwar period led to many notable acquisitions as well: important works by Bill Brandt, Brassaï (plate 35), André Kertész (plate 37), Man Ray (plates 29 and 38), Dora Maar (plate 36), László Moholy-Nagy (plate 39), August Sander (plate 41), and other early-twentieth-century European masters were accessioned into the collection during Coke's tenure. The new additions reflected a partiality for the experimental and surrealist-influenced photography of the time, an interest mirrored in Coke's support of contemporary experimental work, such as that of Lucas Samaras and Ralph Eugene Meatyard. Exhibitions and publications on modern photography carried the department's activities afield at an astonishing pace, and by the time Coke retired in 1987, SFMOMA's photo department was widely regarded as having attained a position rivaled by few in the world.

It was this distinguished program that Sandra S. Phillips inherited the same year. Under her direction, the department began several new initiatives, reflective not only of the curator's interests but also of an evolving understanding of what it means for an art museum to collect photography. Acquisitions since the late 1980s have included classic photographs by established masters of the medium, such as Robert Frank

(plate 51), Alexander Rodchenko (plate 40), and Edward Steichen (plate 26). Recent efforts have been made to expand the collection to include the entire photographic tradition, back to the year of its invention. SFMOMA now displays works by nineteenth-century virtuosos of the medium, such as William Henry Fox Talbot (plate 3), Julia Margaret Cameron (plate 13), and Edouard Baldus, and can offer choice examples of distinctly Victorian photographic technologies, such as the daguerreotype (plates 1 and 2) and the carte de visite. This inclusiveness springs from the growing conviction that photography, from the moment of its introduction in the 1830s, was by its very nature a quintessential manifestation of modernism in the arts.

At the other end of the historical spectrum, photography and its theoretical problems have become increasingly central to a number of contemporary artists who produce work falling into a category loosely termed postmodernist, and in its collecting SFMOMA has been tracking this trend closely. Following the cue of Pop artists and their fascination with popular, mass-appeal art forms (see, e.g., Andy Warhol's photo-booth pictures of the mid-1960s, plates 57 and 58) and the appropriation of photography in the 1970s as part of the conceptual art movement (as in Gordon Matta-Clark, plate 69), a younger generation came to see the medium as central to the aesthetic and political issues surrounding the image culture they wished to explore. David Levinthal, Cindy Sherman (plate 78), and Sandy Skoglund each turned their backs on the idea that photography is a window onto some exterior reality; their photographs are all staged, highlighting the socially constructed nature of such things as official received history or women's roles in the media. Richard Prince and Sherrie Levine use photography in an even more nihilistic fashion: they simply appropriate images made by others, be they the romantic Marlboro Man of cigarette advertisements (plate 79) or famous photographic images by artists like Walker Evans (plate 76). Many of these artists eschew the designation "photographer," because they see themselves as practicing a kind of conceptual art. For them, photography is but one set of materials they might select to work out and convey their ideas.

In its desire to collect, preserve, and display photography in its many manifestations, SFMOMA continues to seek out the most up-to-date and challenging work being produced around the world. Just as in 1935, when cutting-edge contemporary work by the young, little-known Ansel Adams first entered the collection, the Museum remains a laboratory for new ideas and images, constantly questioning the history

of the medium down to its present-day forms. This catalogue, although only a sampling of the approximately ten thousand photographs now in the collection, demonstrates the richness, diversity, and beauty to be found in the photographic medium and stands as a testament to the farsighted people who decided years ago that photographs were something worth cherishing.

plates

The dimensions included in the plate captions
are given in inches followed by centimeters.

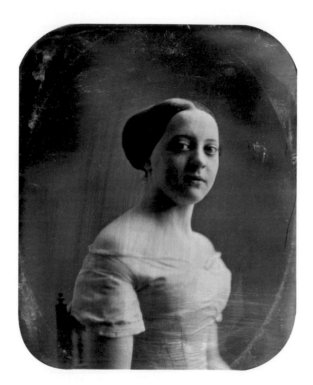

Plate 1

ALBERT SANDS SOUTHWORTH
American, 1811–1894

JOSIAH JOHNSON HAWES
American, 1808–1901

Portrait of a Woman, ca. 1850
daguerreotype, 5½ x 4¾ (14 x 12)

Gift of Dr. Robert Harshorn Shimshak in memory of
Sylvia Dorothy Harshorn Shimshak, 94.414

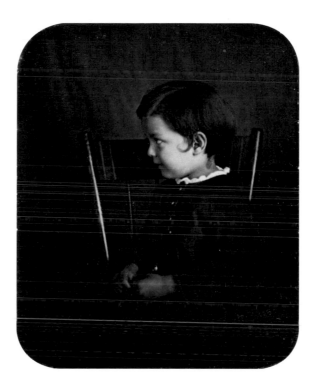

Plate 2

UNKNOWN

Untitled, ca. 1848
daguerreotype, 3¾ x 3¼ (9.5 x 8.3)

Accessions Committee Fund, 94.419

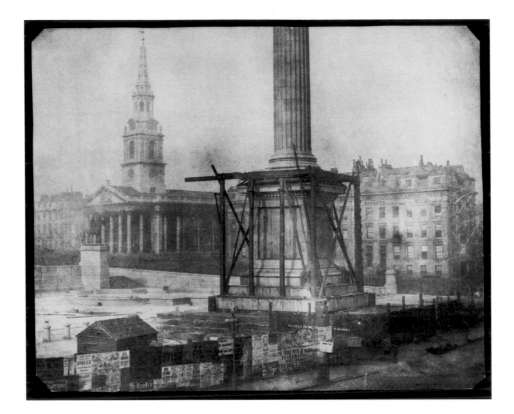

Plate 3

WILLIAM HENRY FOX TALBOT
British, 1800–1877

Nelson's Column under Construction, Trafalgar Square, 1843
salted-paper print from a calotype negative, 6¾ x 8½ (17.1 x 21.6)

Fractional gift of Prentice and Paul Sack, 94.506

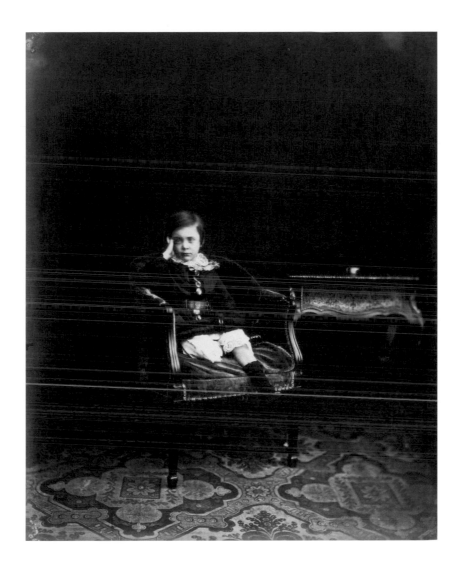

Plate 4

ROGER FENTON
British, 1819–1869

Portrait of Prince Alfred, 1854
salted-paper print, 11 x 9 (27.9 x 22.9)

Accessions Committee Fund: gift of Barbara and Gerson Bakar,
Emily L. Carroll, Leanne B. Roberts, Helen and Charles Schwab,
and Judy C. Webb, 95.129

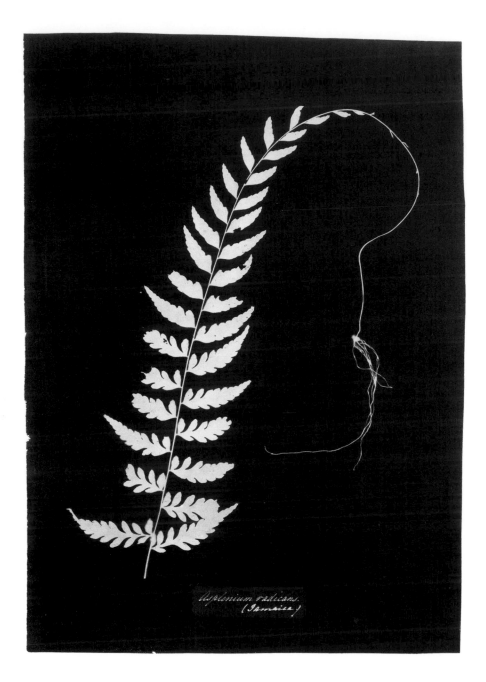

Plate 5

ANNA ATKINS
British, 1799–1871

Asplenium Radicans (Jamaica), ca. 1850
cyanotype photogram, 13 x 9⅛ (33 x 23.2)

Accessions Committee Fund, 94.390

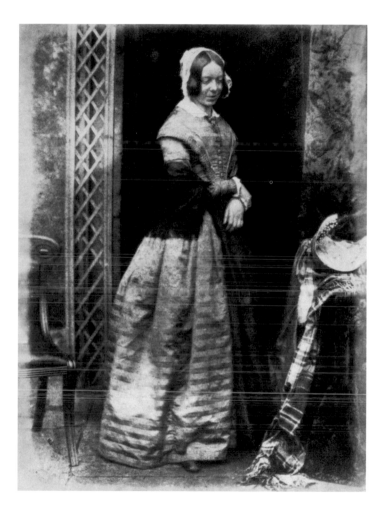

Plate 6

DAVID OCTAVIUS HILL ROBERT ADAMSON
British, 1802–1870 British, 1821–1848

Miss Crampton of Dublin, ca. 1845
salted-paper print from a calotype negative
8 x 5¾ (20.3 x 14.6)

Fractional gift of Prentice and Paul Sack, 96.296

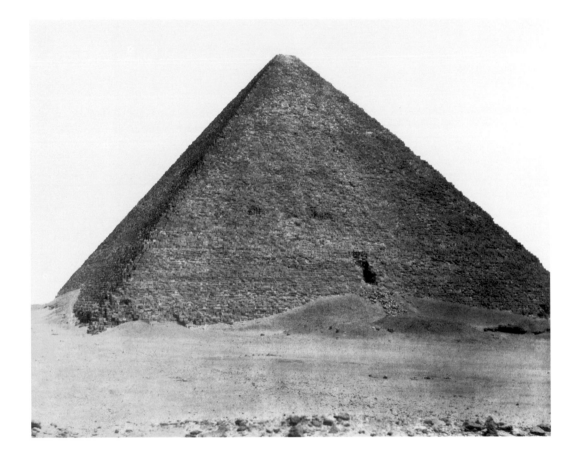

Plate 7

FÉLIX TEYNARD
French, 1817–1892

Djizeh (Nécropole de Memphis)
(Giza [Necropolis of Memphis]), 1851
albumen print, 9¾ x 12¼ (24.8 x 31.1)

Accessions Committee Fund: gift of Leanne B. Roberts, Helen
and Charles Schwab, and the Modern Art Council, 96.194

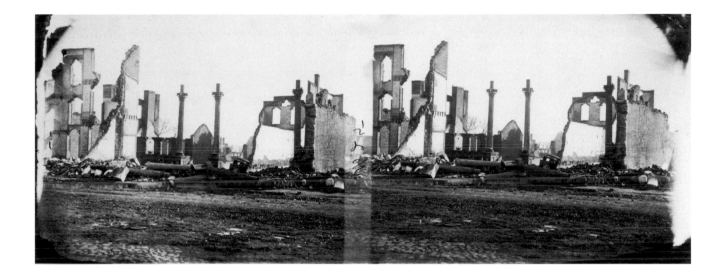

Plate 8

MATHEW BRADY
American, 1823–1896

Southern Express Office, Richmond, Virginia, 1865
uncut stereo albumen print, 4¼ x 10¼ (10.8 x 26)

Members of Foto Forum, 94.394

Plate 9

TIMOTHY H. O'SULLIVAN
American, 1840–1882

Historic Spanish Record of the Conquest.
South Side of Inscription Rock, N.M., 1872
albumen print, 16 x 20 (40.6 x 50.8)

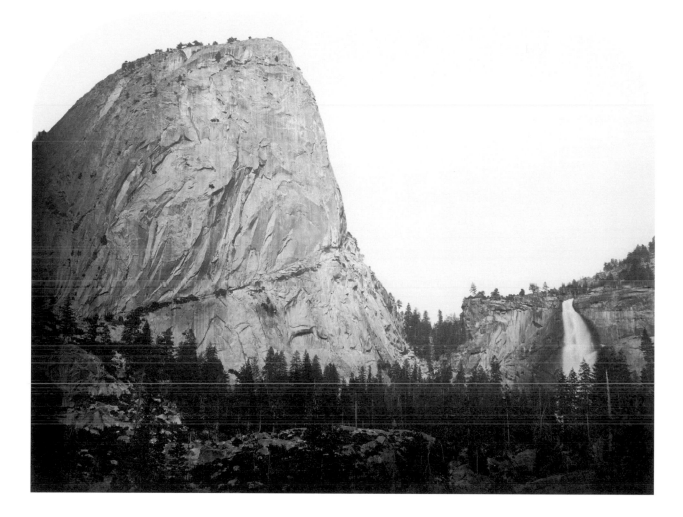

Plate 10

CARLETON E. WATKINS
American, 1829–1916

Mt. Broderick, Nevada Fall, 700 ft., Yosemite, 1861
albumen print, 16 x 21 (40.6 x 53.3)

Purchased through a gift of Judy and John Webb, Sande
Schlumberger, Pat and Bill Wilson, Susan and Robert Green,
the Miriam and Peter Haas Fund, Accessions Committee Fund,
and Mr. and Mrs. Max Herzstein and Mrs. Myrtle Lowenstern
in honor of Mr. and Mrs. Stanley Herzstein's fiftieth wedding
anniversary, 95.98

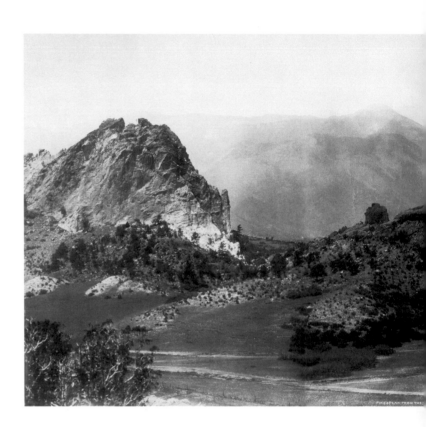

Plate 11

WILLIAM HENRY JACKSON
American, 1843–1942

Pike's Peak from the Garden of the Gods, 1888
albumen print, 20¼ x 70¼ (51.4 x 178.4)

Purchased through a gift of the Judy Kay Memorial Fund,
96.182

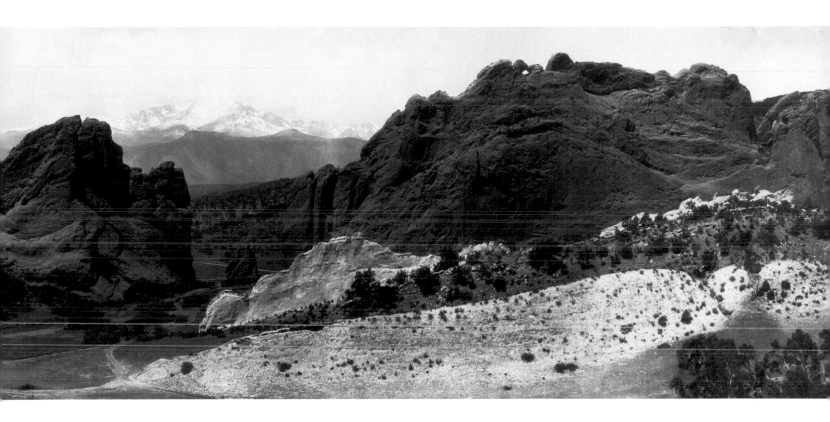

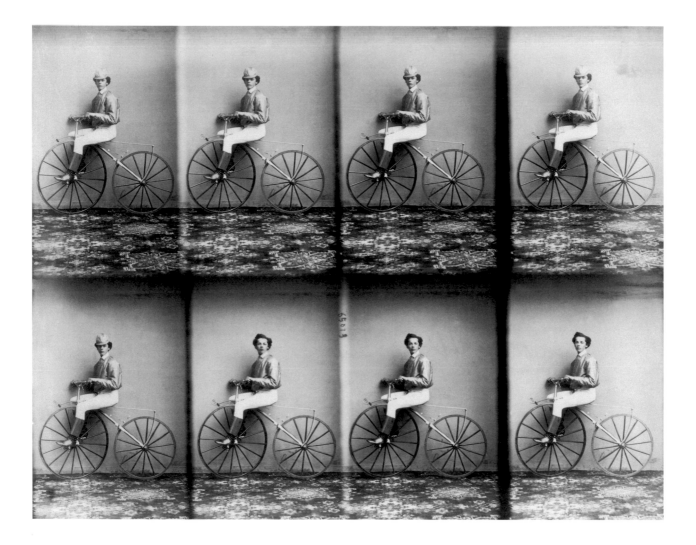

Plate 12

ANDRÉ-ADOLPHE-EUGÈNE DISDERI
French, 1819–1889

Michaud sur son vélocipède
(Michaud on His Velocipede), 1867
albumen print, 7 x 9 (17.8 x 22.9)

Accessions Committee Fund, 95.264

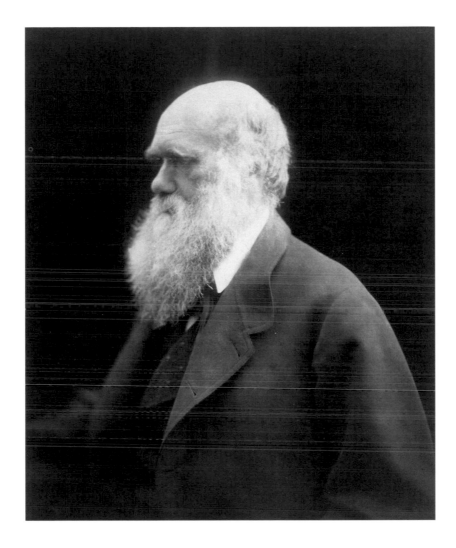

Plate 13

JULIA MARGARET CAMERON
British, 1815–1879

Charles Darwin, 1868
albumen print, 11½ x 9½ (29.2 x 24.1)

Accessions Committee Fund: gift of Frances and John Bowes,
Madeleine H. Russell, Danielle and Brooks Walker, Jr., and the
Modern Art Council, 94.395

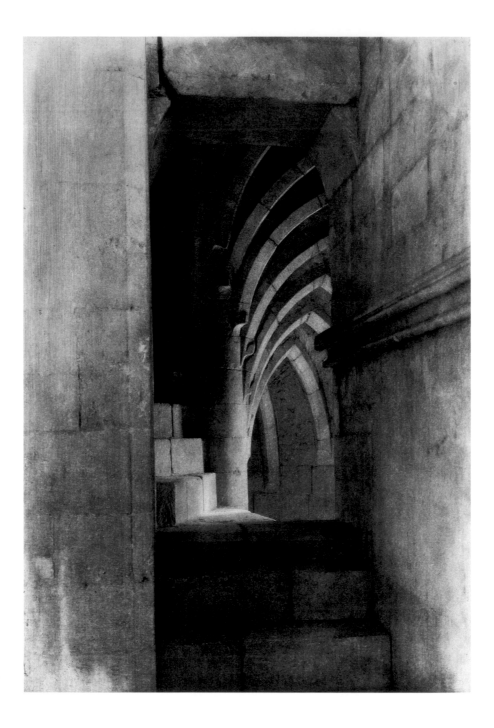

Plate 14

FREDERICK H. EVANS
British, 1853–1943

Lincoln Cathedral: Stairway in S.W. Turret, 1898
photogravure, 7⅞ x 5⅜ (20 x 13.7)

The Margaret Weston Collection, fractional gift of Sandra
Mosbacher, 97.157

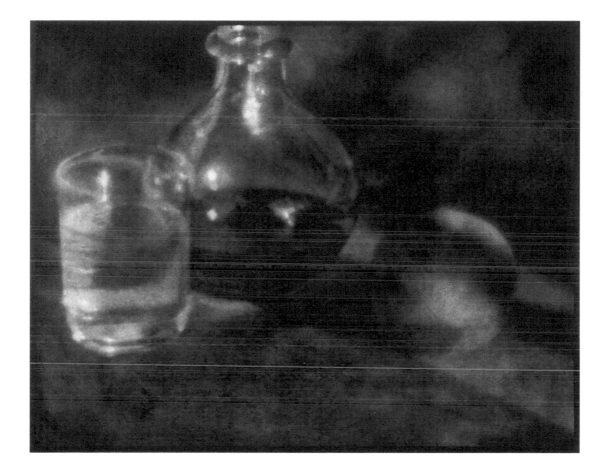

Plate 15

HEINRICH KÜHN
German, 1866–1944

Still Life, ca. 1900
oil-transfer print, 9⅛ x 11¾ (23.2 x 29.8)

The Margaret Weston Collection, fractional gift of
Sandra Mosbacher, 97.169

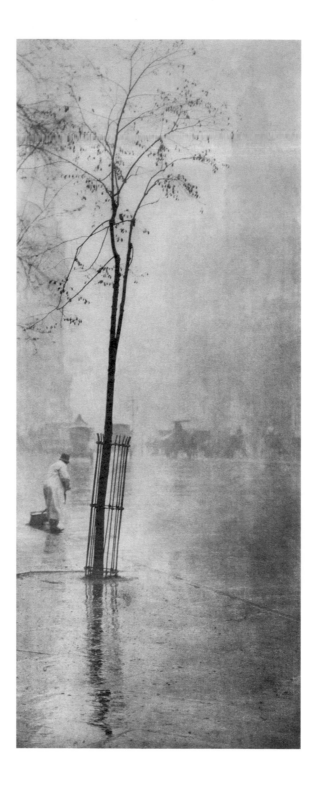

Plate 16

ALFRED STIEGLITZ
American, 1864–1946

Spring Showers, New York, 1900
photogravure on vellum, 12¼ x 5 (31.1 x 12.7)

Alfred Stieglitz Collection, gift of Georgia O'Keeffe, 52.1855

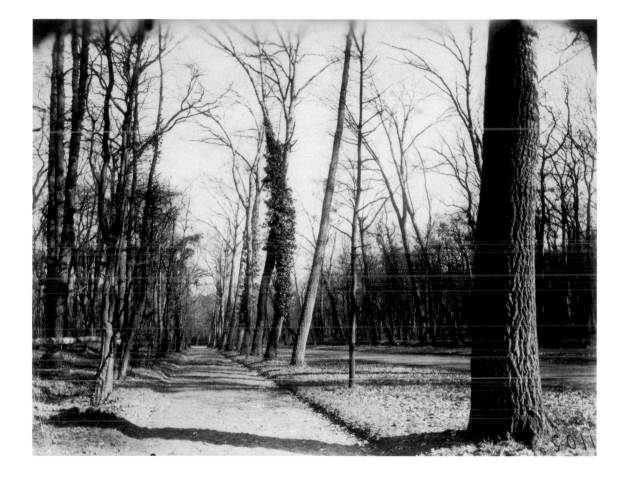

Plate 17

EUGÈNE ATGET
French, 1857–1927

Tree-lined Path, ca. 1910
gold-toned printing-out paper, 7 x 8¾ (17.8 x 22.2)

Accessions Committee Fund: gift of Frances and John Bowes,
Shawn and Brook Byers, Jean and Jim Douglas, Mimi and Peter
Haas, Evelyn D. Haas, Maria Monet Markowitz and Jerome
Markowitz, Madeleine H. Russell, Judy and John Webb, and
the Modern Art Council, 97.145

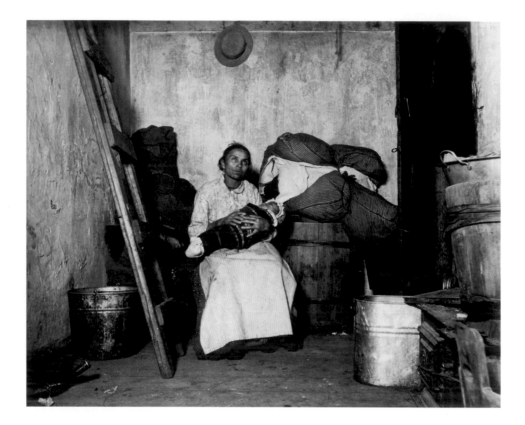

Plate 18

JACOB RIIS
American, born Denmark, 1849–1914

Home of an Italian Ragpicker, Jersey Street, 1894
gelatin silver print, 7¾ x 9¾ (19.7 x 24.8)

Evelyn and Walter Haas Fund, 95.145

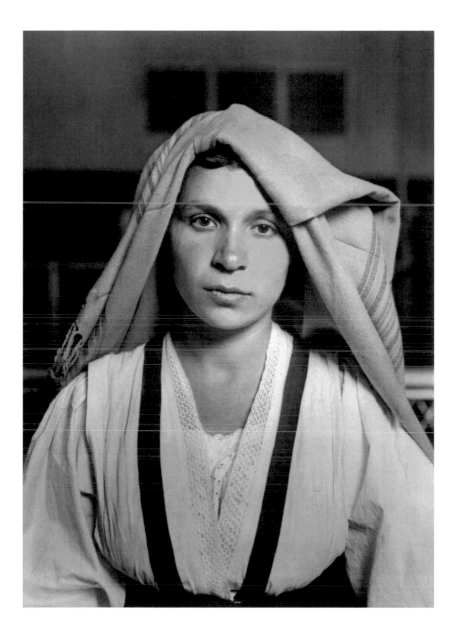

Plate 19

LEWIS HINE
American, 1874–1940

*Woman with Folded Headdress,
Ellis Island, New York,* 1905
gelatin silver print, 6⅛ x 4½ (15.5 x 11.4)

Gift of Sandra Mosbacher, 93.100

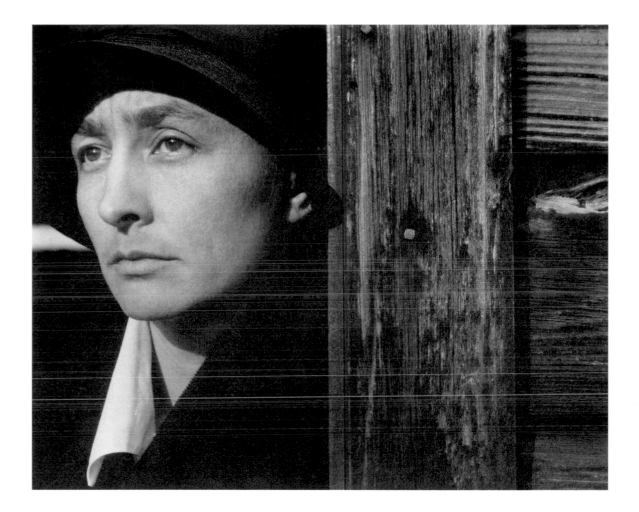

Plate 20

ALFRED STIEGLITZ
American, 1864–1946

Georgia O'Keeffe, 1922
palladium print, 7¾ x 9½ (19.7 x 24.1)

Alfred Stieglitz Collection, gift of Georgia O'Keeffe, 52.1814

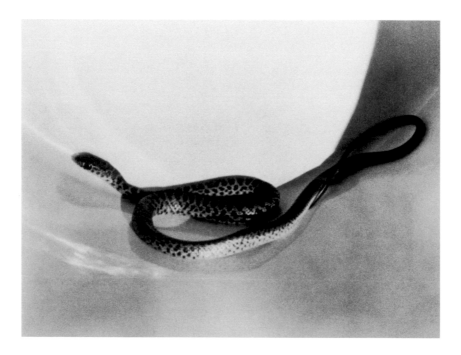

Plate 21

IMOGEN CUNNINGHAM
American, 1883–1976

Snake in Bucket, 1929
gelatin silver print, 3 7/16 x 4½ (8.7 x 11.4)

The Henry Swift Collection, gift of Florence Alston Swift, 63.19.115

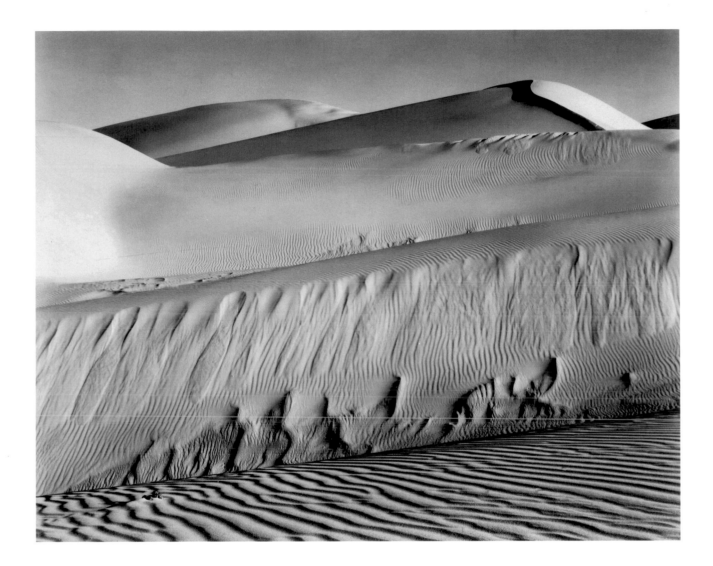

Plate 22

EDWARD WESTON
American, 1886–1958

Dunes, Oceano, 1936
gelatin silver print, 7⁹⁄₁₆ x 9⁹⁄₁₆ (19.2 x 24.3)

Albert M. Bender Collection, Albert M. Bender Bequest Fund
purchase, 62.1173

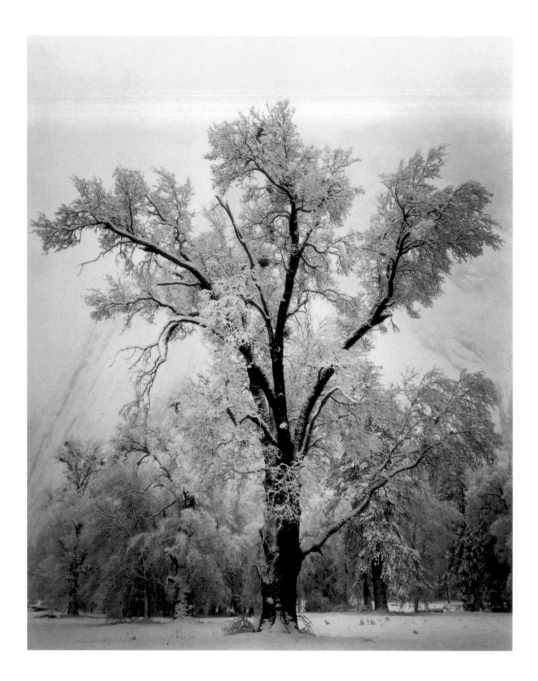

Plate 23

ANSEL ADAMS
American, 1902–1984

Oak Tree, Snowstorm, Yosemite, 1948
gelatin silver print, 9⅜ x 7⅜ (23.8 x 18.7)

Gift of Mrs. Walter A. Haas, 78.83.9

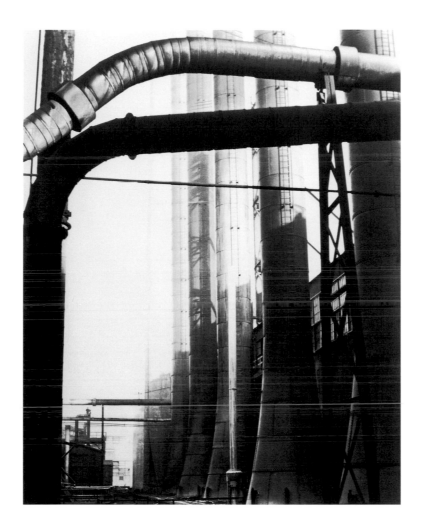

Plate 24

EDWARD WESTON
American, 1886–1958

Pipes and Stacks, 1922
gelatin silver print, 9⁷⁄₁₆ x 7⁹⁄₁₆ (24 x 19.2)

Albert M. Bender Collection, Albert M. Bender Bequest Fund
purchase, 62.1182

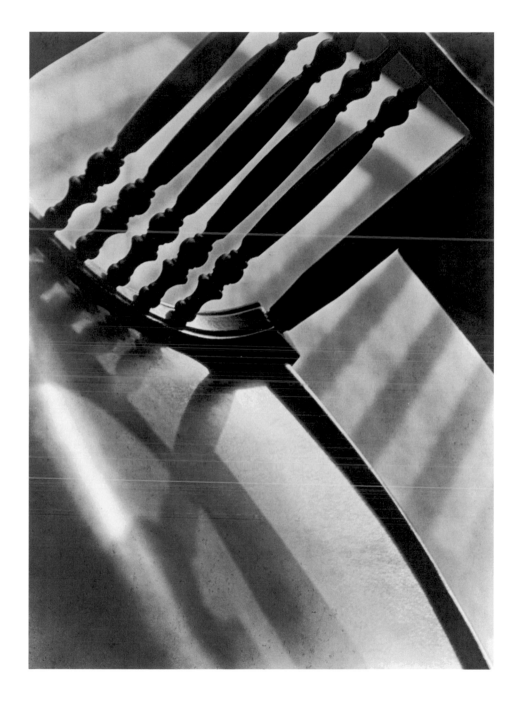

Plate 25

PAUL STRAND
American, 1890–1976

Chair Abstract, Twin Lakes, Connecticut, 1916
palladium print, 13 x 9 11/16 (33 x 24.6)

Purchase, 84.15

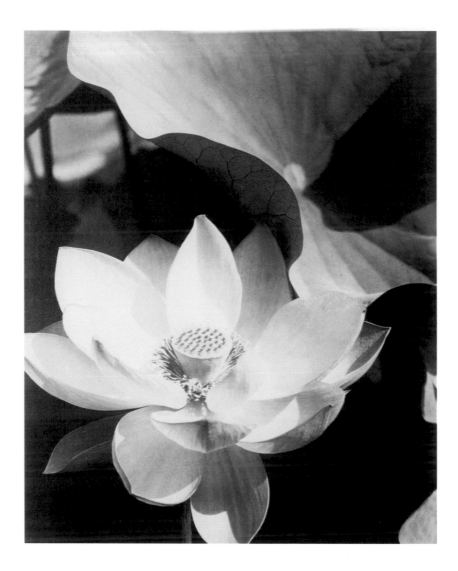

Plate 26

EDWARD J. STEICHEN
American, born Luxembourg, 1870–1973

Lotus, Mount Kisco, New York, 1915
gelatin silver print, 9⅝ x 7⅝ (24.4 x 19.4)

The Margaret Weston Collection, fractional gift of
Sandra Mosbacher, 97.172

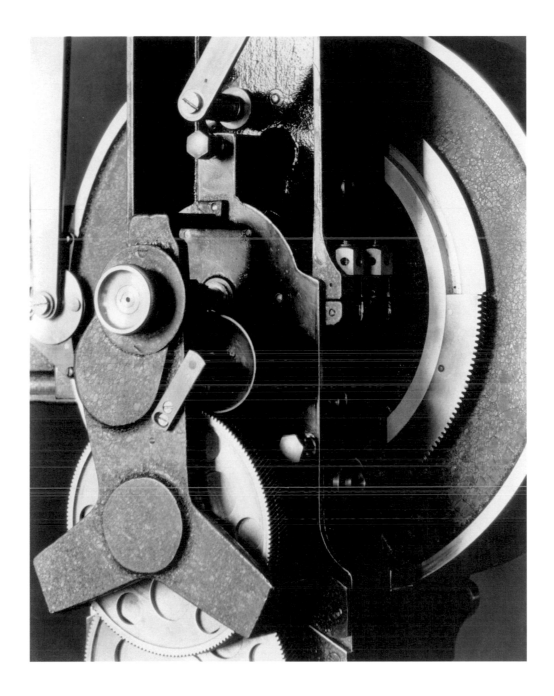

Plate 27

PAUL STRAND
American, 1890–1976

Double Akeley, New York, 1922
gelatin silver print, 9¹¹⁄₁₆ x 7¾ (24.6 x 19.7)

The Helen Crocker Russell and William H. and Ethel W. Crocker
Family Funds purchase, 80.83

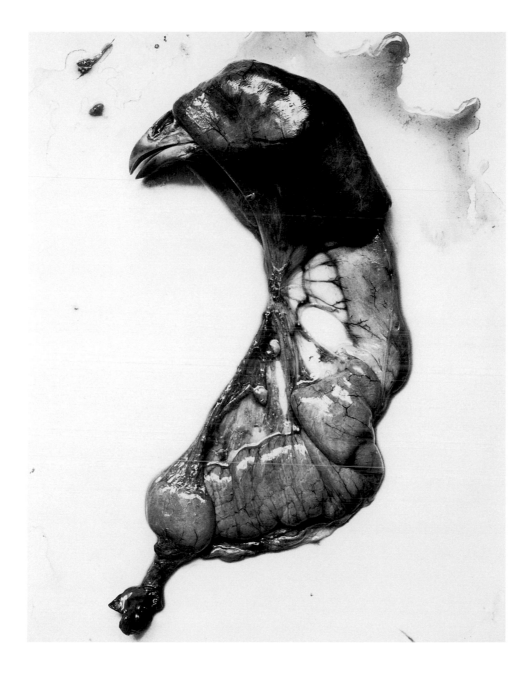

Plate 28

FREDERICK SOMMER
American, born Italy, 1905

Chicken Entrails, 1939
gelatin silver print, 10 x 8 (25.4 x 20.3)

Gift of Brett Weston, 83.410

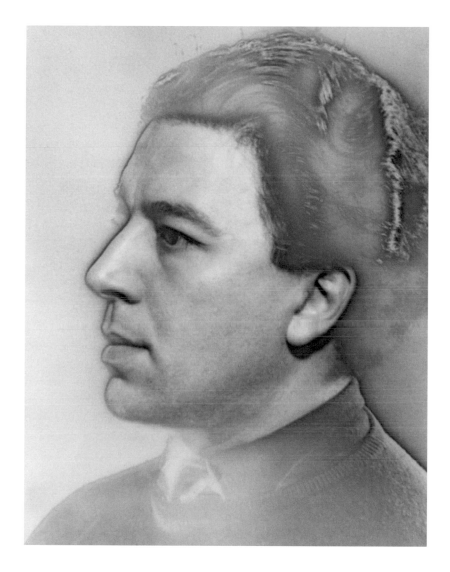

Plate 29

MAN RAY
American, 1890–1976

André Breton, ca. 1928
gelatin silver print, 9⅛ x 7⅛ (23.2 x 18.1)

Purchase, 84.57

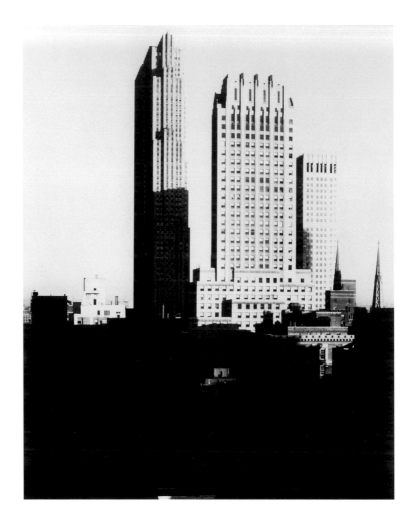

Plate 30

ALFRED STIEGLITZ
American, 1864–1946

From the Shelton Looking West, 1935–36
gelatin silver print, 9⅝ x 7⁹⁄₁₆ (24.4 x 19.2)

Alfred Stieglitz Collection, gift of Georgia O'Keeffe, 52.1825

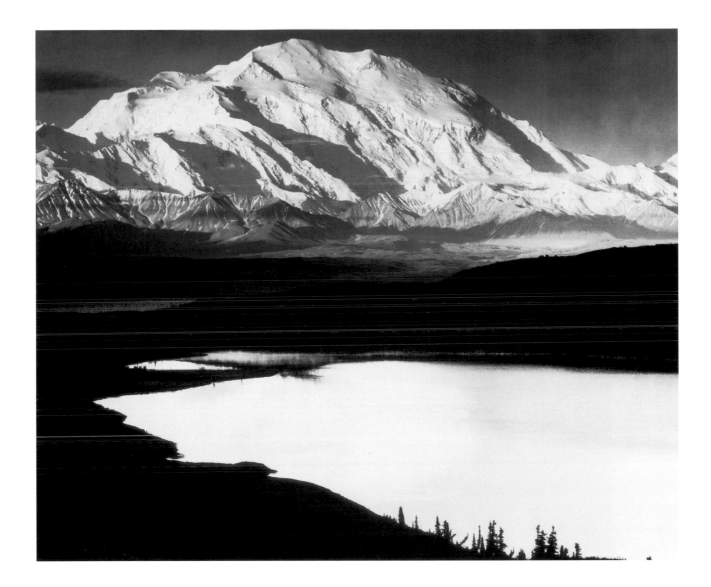

Plate 31

ANSEL ADAMS
American, 1902–1984

Mount McKinley and Wonder Lake,
Denali National Park, Alaska, 1947
gelatin silver print, 40 x 48½ (101.6 x 123.2)

Gift of Alfred Fromm, Otto Meyer, and Louis A. Petri,
San Francisco, 74.52.1

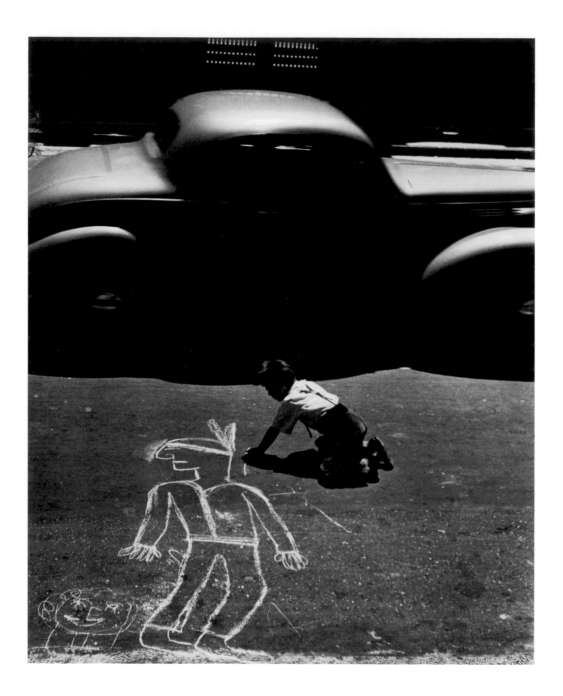

Plate 32

JOHN GUTMANN
American, born Germany, 1905–1998

The Artist Lives Dangerously, 1938
gelatin silver print, 9¼ x 7½ (23.5 x 19.1)

Gift of Foto Forum, 86.37

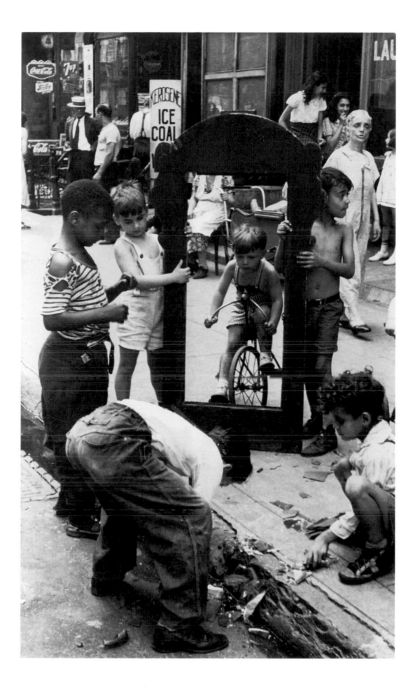

Plate 33

HELEN LEVITT
American, born 1913

New York, 1939
gelatin silver print, 7½ x 4⅝ (19.1 x 11.7)

Purchased through a gift of Prentice and Paul Sack, 89.177

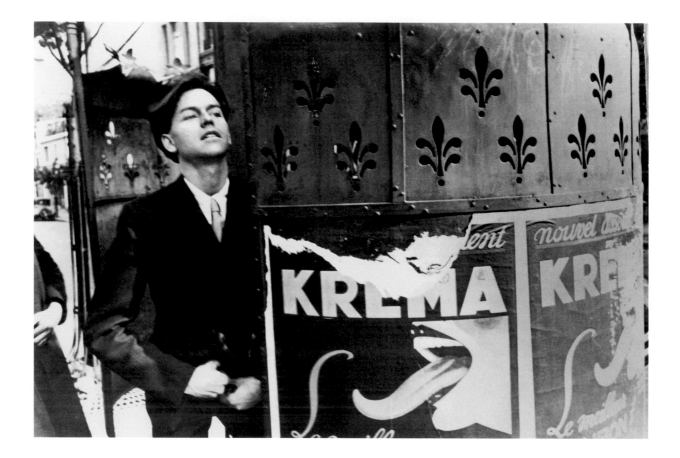

Plate 34

HENRI CARTIER-BRESSON
French, born 1908

Untitled (Charles Henri Ford), 1932
gelatin silver print, 6⅜ x 9⅜ (16.2 x 23.8)

Purchased through a gift of Byron Meyer, 87.95

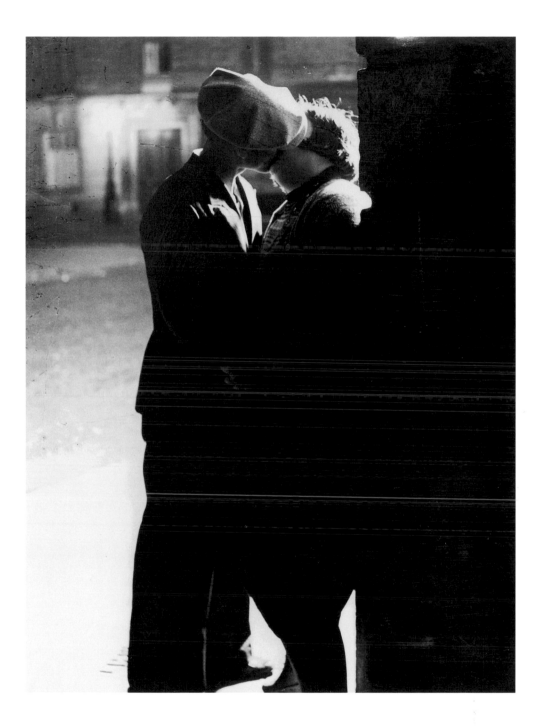

Plate 35

BRASSAÏ (Gyula Halász)
French, born Transylvania, 1899–1984

Untitled, ca. 1932
gelatin silver print, 11 5/16 x 8 9/16 (28.7 x 21.7)

Helen Crocker Russell and William H. and Ethel W. Crocker Family Funds, 80.343

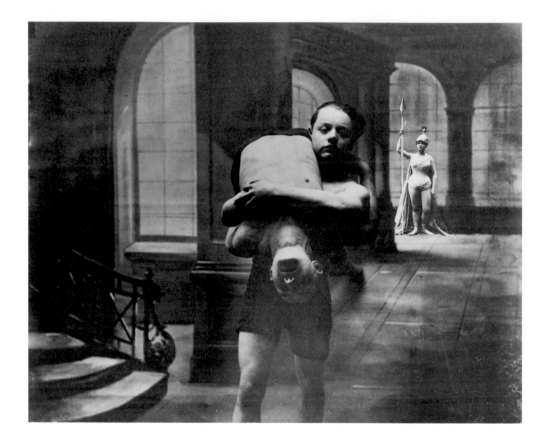

Plate 36

DORA MAAR
French, born England, 1909–1997

Untitled, ca. 1940
gelatin silver print photomontage
8⅝ x 10⁹⁄₁₆ (21.9 x 26.8)

Fund of the 80s purchase, 84.150

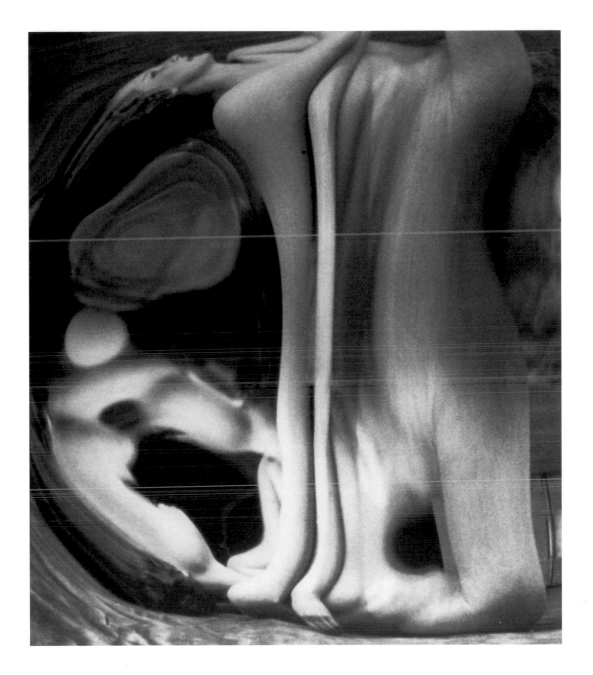

Plate 37

ANDRÉ KERTÉSZ
American, born Hungary, 1894–1985

Distortion #129, 1932
gelatin silver print, 7¹³/₁₆ x 6⁷/₈ (19.8 x 17.5)

Fund of the 80s purchase, 85.124

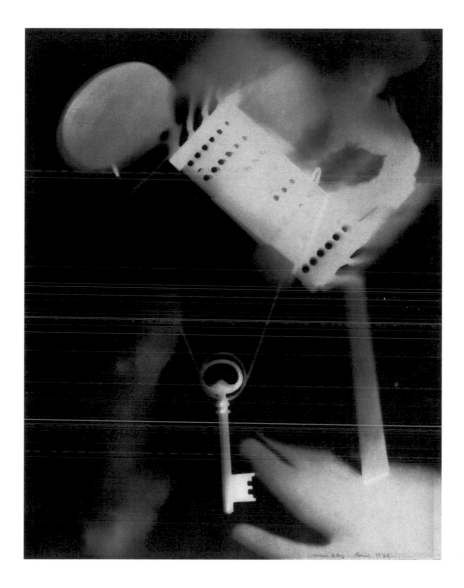

Plate 38

MAN RAY
American, 1890–1976

Untitled, 1922
gelatin silver print (Rayograph)
11 15/16 x 9 3/8 (30.3 x 23.8)

Purchase, 82.151

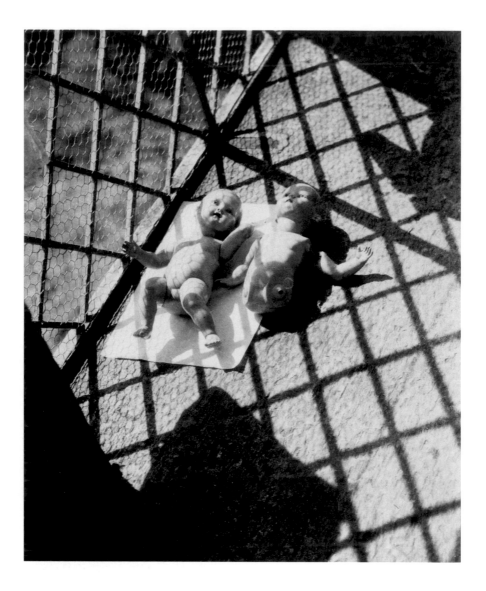

Plate 39

LÁSZLÓ MOHOLY-NAGY
American, born Hungary, 1895–1946

Puppen (In der Mittagsonne; Puppen im Sonnenbad)
(Dolls [In the Midday Sun; Dolls Taking a Sunbath]), 1926
gelatin silver print, 9 11/16 x 7 7/8 (24.6 x 20)

Purchase, 82.26

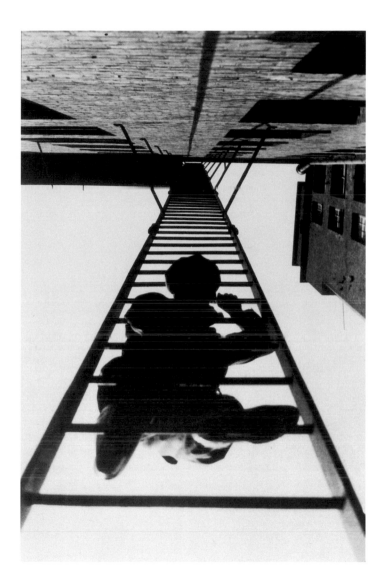

Plate 40

ALEXANDER RODCHENKO
Russian, 1891–1956

Fire Escape, from the series
House on Myasnicka Street, 1925
gelatin silver print, 9 x 6 (22.9 x 15.2)

Accessions Committee Fund: gift of Frances and John Bowes,
Evelyn Haas, Mimi and Peter Haas, Pam and Dick Kramlich,
and Judy and John Webb, 96.191

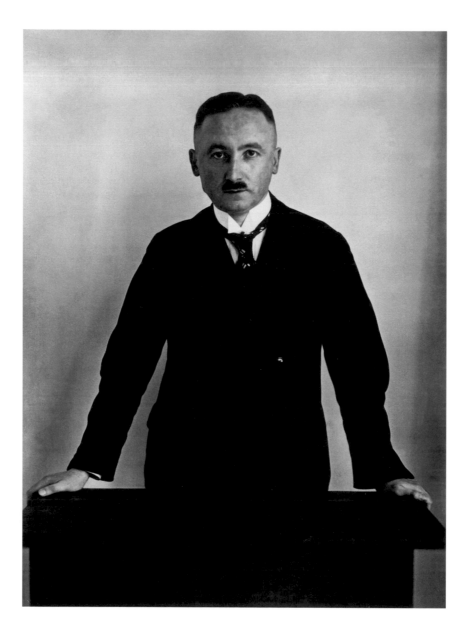

Plate 41

AUGUST SANDER
German, 1876–1964

Studienrat (Assistant Schoolmaster), 1928
gelatin silver print, 7⅞ x 5⅞ (20 x 15)

Clinton Walker Fund Purchase, 84.63

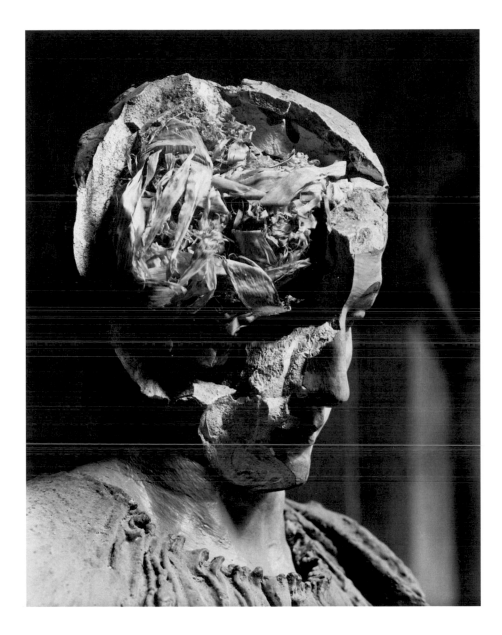

Plate 42

JOSEF SUDEK
Czechoslovakian, 1896–1976

Sádrová Hlava (Empty Head), 1945
gelatin silver print, 6¼ x 4¹³⁄₁₆ (15.9 x 12.3)

Byron Meyer Fund purchase, 85.150

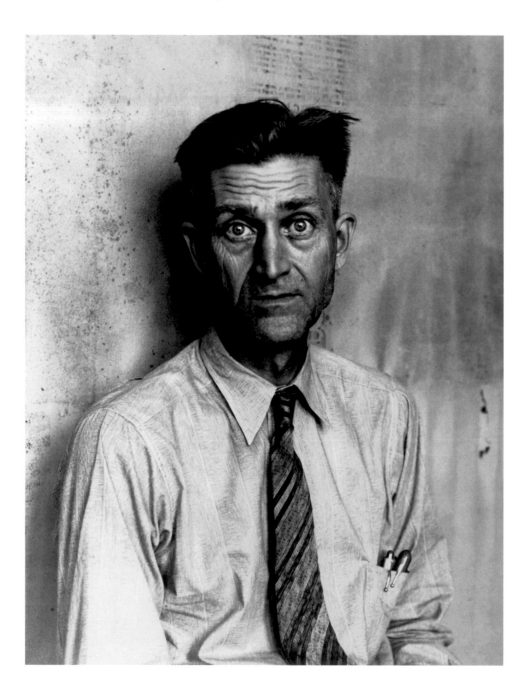

Plate 43

DOROTHEA LANGE
American, 1895–1965

*J. R. Butler, president of the Southern Tenant Farmers'
Union, Memphis, Tennessee, June 1938,* 1938
gelatin silver print, 9¹⁵/₁₆ x 7¹⁵/₁₆ (25.2 x 20.2)

Purchased through a gift of The Robert Mapplethorpe Foundation
and Accessions Committee Fund: gift of Frances and John Bowes,
Elaine McKeon, Collectors Forum, and the Modern Art Council, 93.42

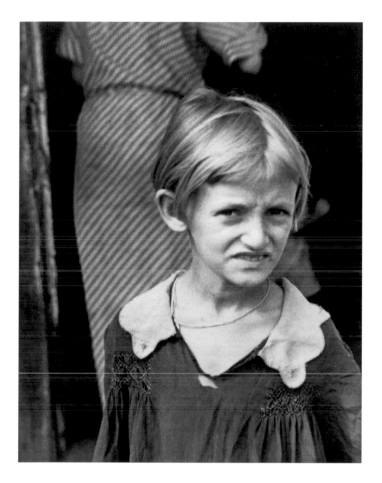

Plate 44

WALKER EVANS
American, 1903–1975

Untitled, 1935
gelatin silver print, 9^{15}/$_{16}$ x 8 (25.2 x 20.3)

Accessions Committee Fund and Members of Foto Forum, 93.92

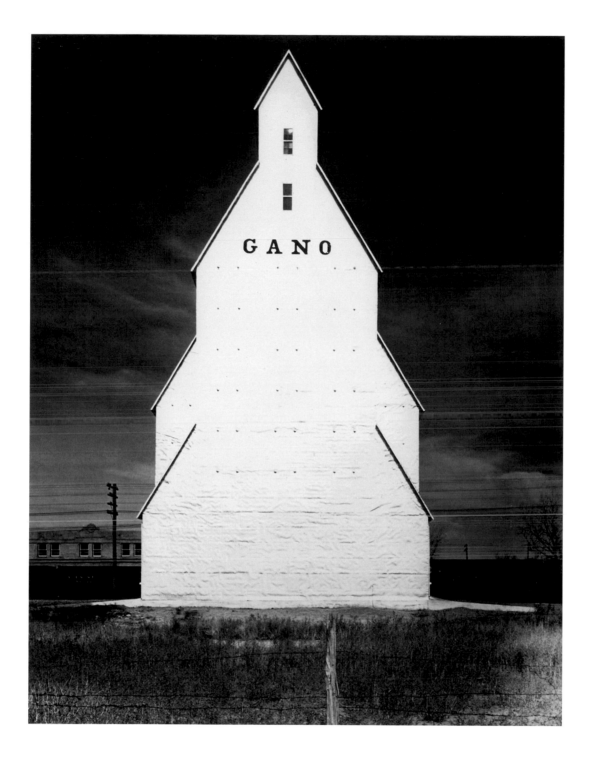

Plate 45

WRIGHT MORRIS
American, 1910–1998

Gano Grain Elevator, Western Kansas, 1940
gelatin silver print, 13⅝ x 10⅝ (34.6 x 27)

Mortimer Fleishhacker, Jr., Memorial Fund Purchase, 83.71

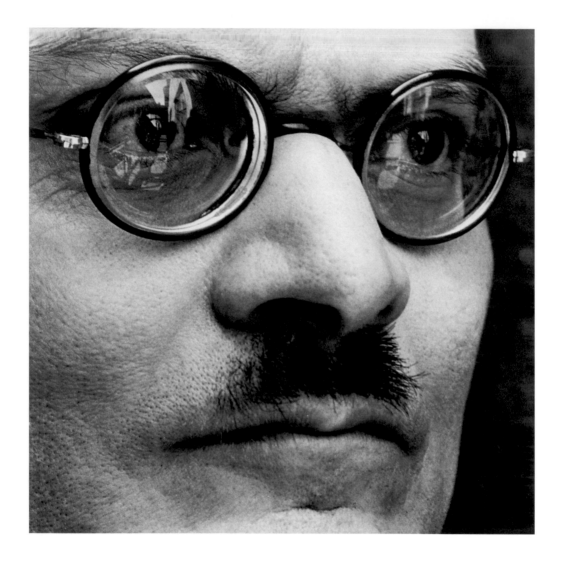

Plate 46

ANSEL ADAMS
American, 1902–1984

Orozco (José Clemente Orozco), 1933
gelatin silver print, 5¹³⁄₁₆ x 5⅞ (14.8 x 14.9)

Albert M. Bender Collection, gift of Albert M. Bender, 35.4502

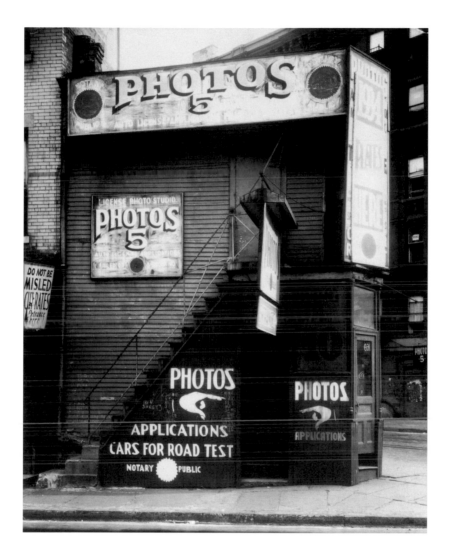

Plate 47

WALKER EVANS
American, 1903–1975

License Photo Studio, New York City, 1934
gelatin silver print, 9 15/16 x 7 15/16 (25.2 x 20.2)

Foto Forum purchase, 89.68

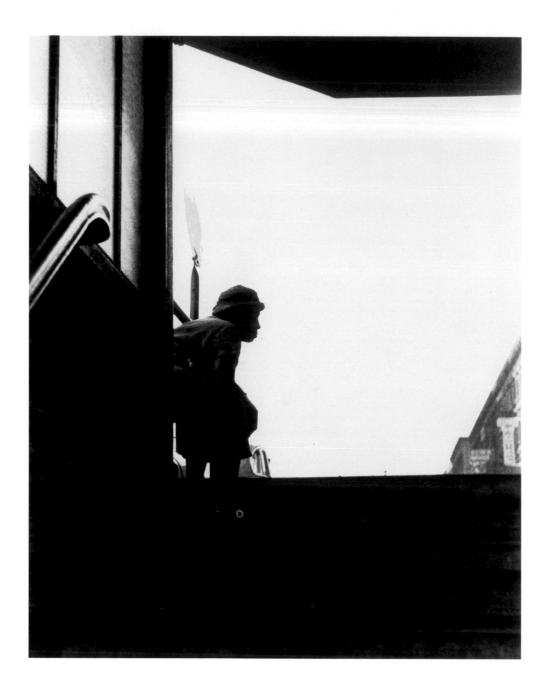

Plate 48

ROY DeCARAVA
American, born 1919

Woman Resting, Subway Entrance, New York, 1952
gelatin silver print, 13⅛ x 9⅛ (33.3 x 23.1)

The Helen Crocker Russell and William H. and Ethel W. Crocker Family
Funds purchase, 80.27

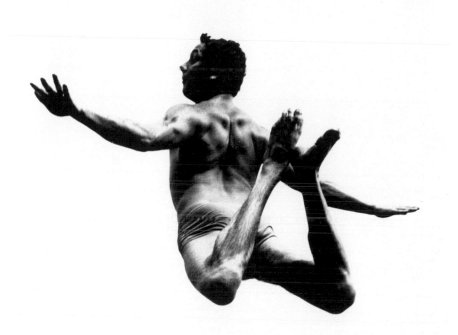

Plate 49

AARON SISKIND
American, 1903–1991

Untitled (#99), from the series
Pleasures and Terrors of Levitation, 1953
gelatin silver print, 4⅝ x 4⅝ (11.7 x 11.7)

Gift of Virginia Hassel Ballinger in memory of Paul Hassel, 73.56.10

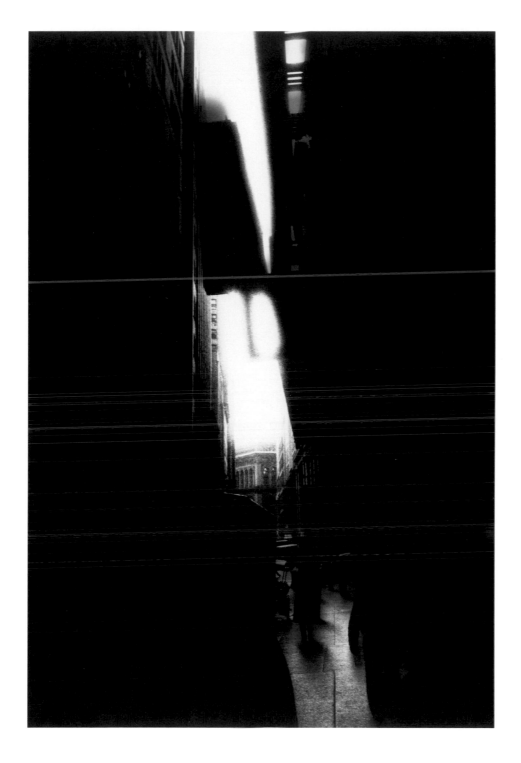

Plate 50

WILLIAM KLEIN
American, born 1928

Black Fire Escapes near Wall Street, New York, 1954
gelatin silver print, 13¾ x 10¾ (34.9 x 27.5)

Accessions Committee Fund, 94.334

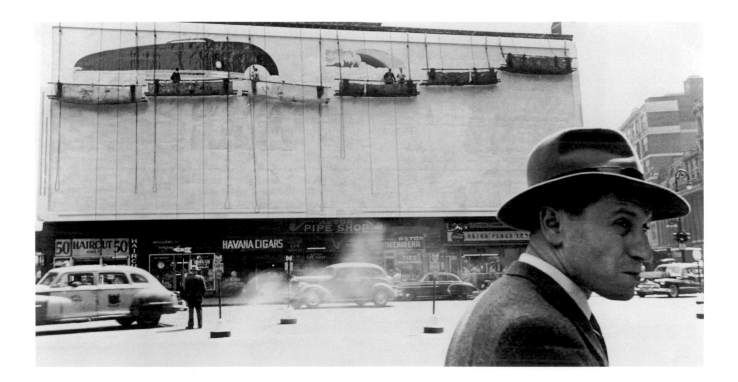

Plate 51

ROBERT FRANK
American, born Switzerland, 1924

Astor Place, 1949
gelatin silver print, 7 x 13¼ (17.8 x 33.7)

Accessions Committee Fund: gift of Doris and Donald G. Fisher,
Elaine McKeon, Leanne B. Roberts, Danielle and Brooks Walker, Jr.,
Mrs. Paul L. Wattis, and Thomas W. Weisel and Emily L. Carroll,
92.233

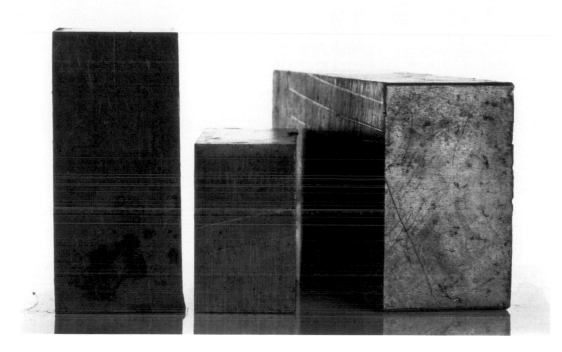

Plate 56

IRVING PENN
American, born 1917

Three Steel Blocks, 1980
platinum-palladium print, 16 x 24 (40.6 x 61)

Gift of Alexander Liberman, 85.775

Plate 57 (left)

ANDY WARHOL
American, 1928–1987

Untitled (Jim Brody, Timothy Baum), ca. 1966
gelatin silver print, 8 x 1 5/8 (20.3 x 4.1)

Accessions Committee Fund, 94.525

Plate 58 (right)

ANDY WARHOL
American, 1928–1987

Untitled (Taylor Mead), ca. 1966
gelatin silver print, 8 x 1 5/8 (20.3 x 4.1)

Accessions Committee Fund: gift of Barbara and Gerson Bakar,
Jean and Jim Douglas, Madeleine H. Russell, and Norah and
Norman Stone, 94.524

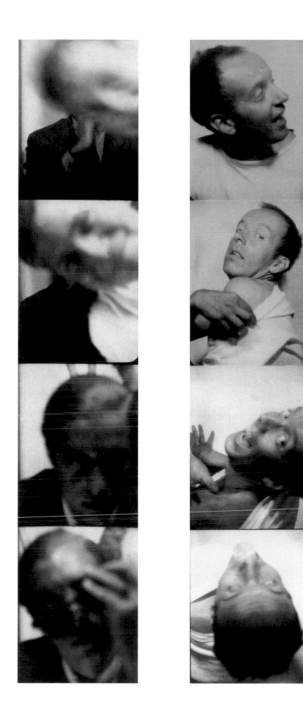

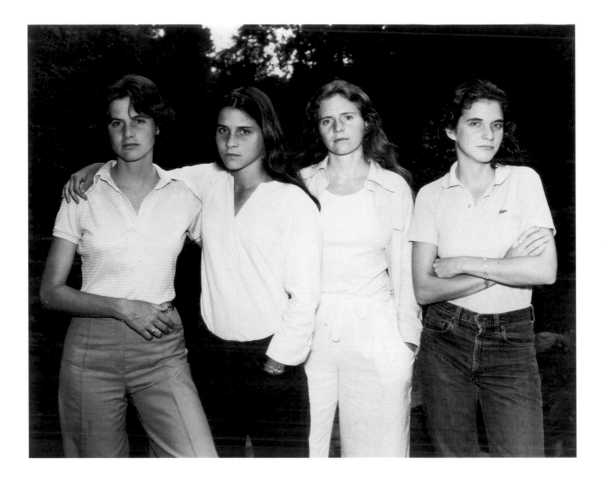

Plate 59

NICHOLAS NIXON
American, born 1947

The Brown Sisters, New Canaan, Connecticut, 1975
gelatin silver print, 7 ⁵⁄₈ x 9 ⁵⁄₈ (19.4 x 24.4)

Accessions Committee Fund, 90.323

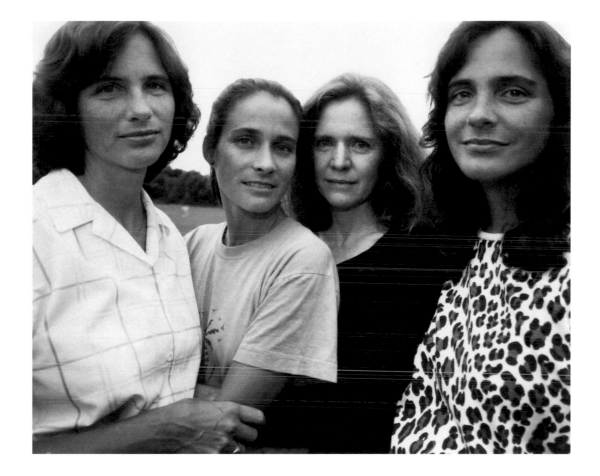

Plate 60

NICHOLAS NIXON
American, born 1947

The Brown Sisters, Wellesley, Massachusetts, 1988
gelatin silver print, 7¹⁵/₁₆ x 9¹⁵/₁₆ (20.2 x 25.2)

Foto Forum Fund, 92.60

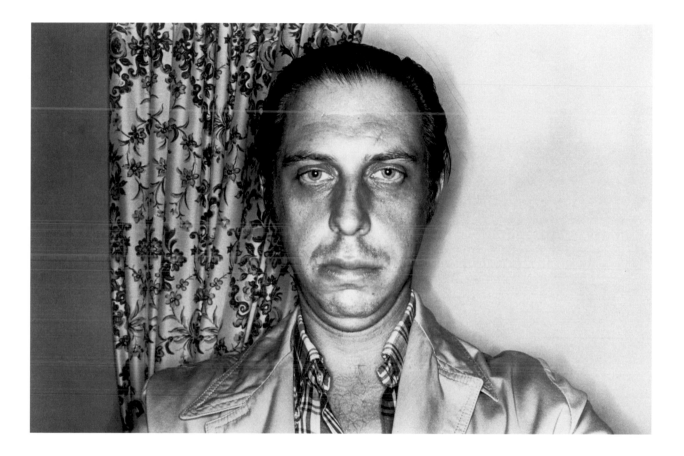

Plate 61

LEE FRIEDLANDER
American, born 1934

Self-Portrait, 1969
gelatin silver print, 7 9/16 x 11 5/16 (19.2 x 28.7)

Sale of Paintings Fund, 83.27

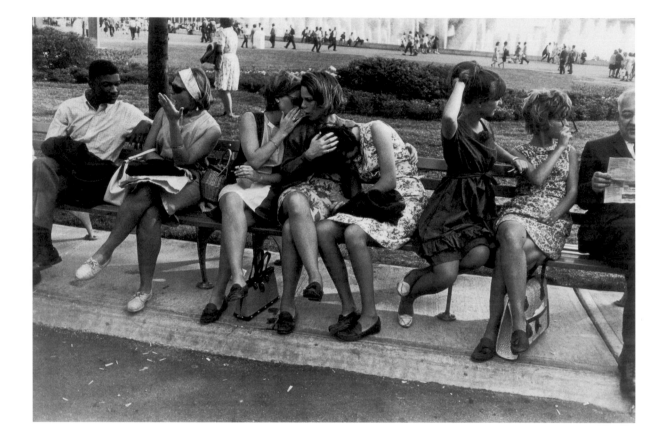

Plate 62

GARRY WINOGRAND
American, 1928–1984

World's Fair, New York City, 1964
gelatin silver print, 8⅝ x 13 (21.9 x 33)

Gift of Dr. L. F. Peede, Jr., 83.467

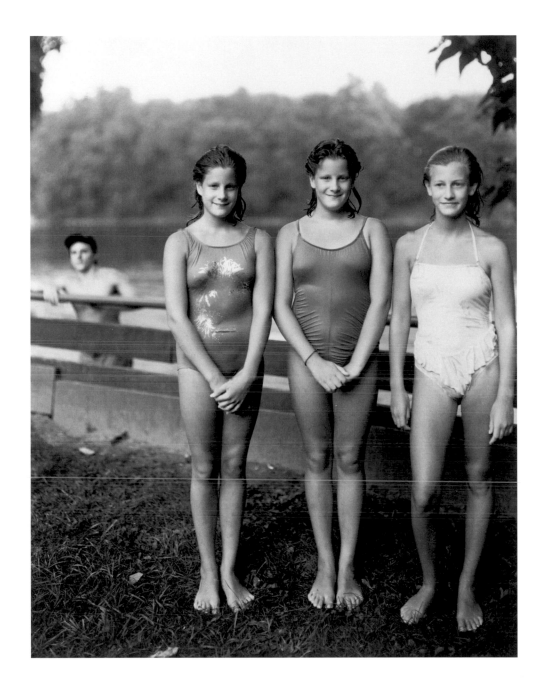

Plate 63

JUDITH JOY ROSS
American, born 1946

Untitled, from the series *Easton Portraits,* 1988
gelatin silver print, 10 x 8 (25.4 x 20.3)

Purchased through a gift of Jonathan Morgan and
Foto Forum Funds, 91.144

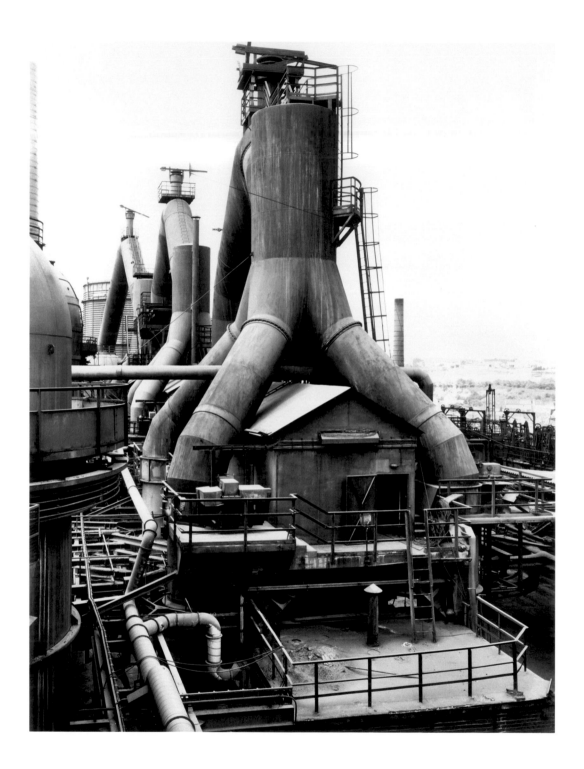

Plate 64

BERND BECHER HILLA BECHER
German, born 1931 German, born 1934

Blast Furnace: View 2, Völklingen, Saar, Germany, 1986
gelatin silver print, 24 x 20 (61 x 50.8)

Accessions Committee Fund, 94.152

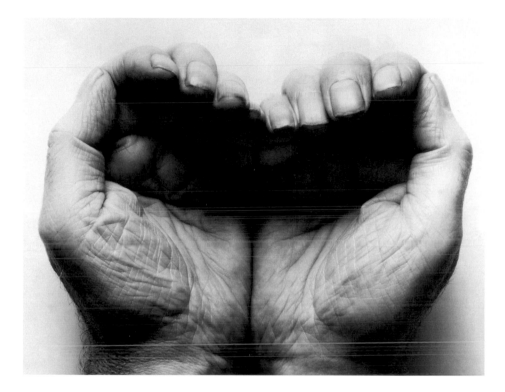

Plate 65

JOHN COPLANS
British, born 1920

Double Hand, Front, 1988
gelatin silver print, 40 x 54 (101.6 x 137.2)

Gift of Carol Ross, 95.175

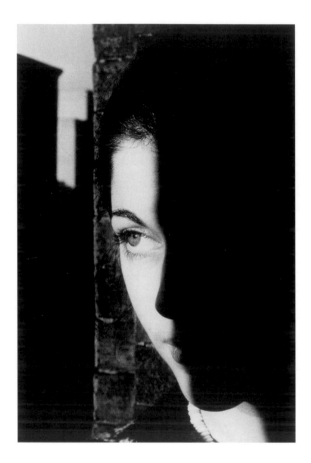

Plate 66

RALPH GIBSON
American, born 1939

Untitled, 1974
gelatin silver print, 12⅜ x 8³⁄₁₆ (31.4 x 20.8)

Sale of Paintings Fund, 82.23

Plate 67

DAIDO MORIYAMA
Japanese, born 1938

Untitled, from the series *Light and Shadow,* ca. 1979–80
gelatin silver print, 17 9/16 x 21 5/8 (44.6 x 54.9)

Accessions Committee Fund, 93.222

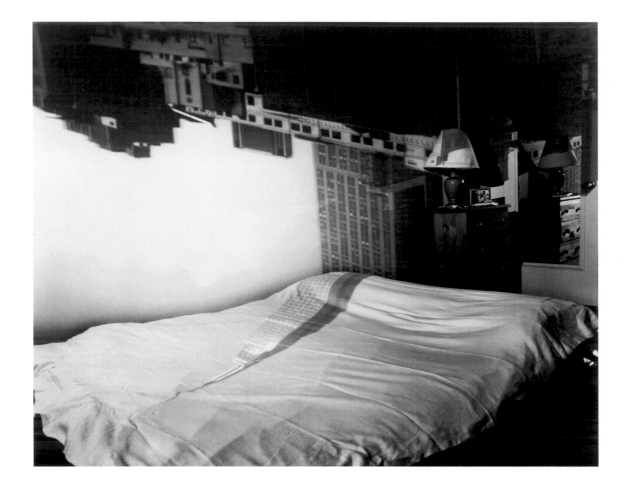

Plate 68

ABELARDO MORELL
American, born Cuba, 1948

*Camera Obscura Image of the Empire State
Building in Bedroom,* 1994
gelatin silver print, 20 x 24 (50.8 x 61)

Gift of the artist in memory of Bill Beckler, 94.362

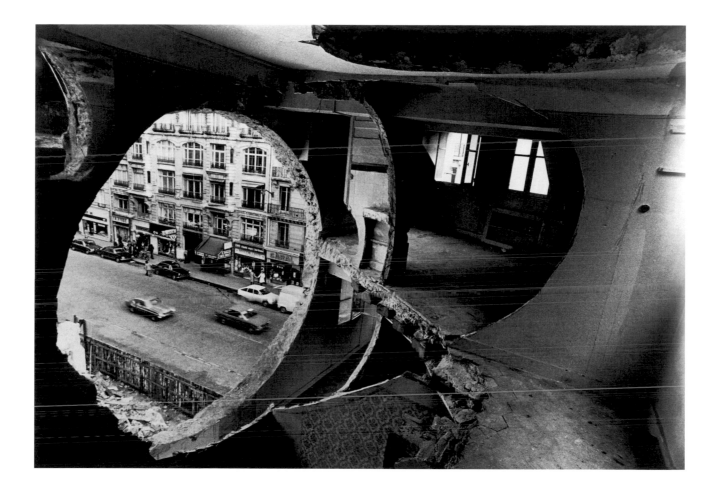

Plate 69

GORDON MATTA-CLARK
American, 1945–1978

Conical Intersect, 1975
gelatin silver print, 10⅝ x 15⅝ (26.9 x 39.7)

Accessions Committee Fund: gift of Frances and John Bowes, Pam and
Dick Kramlich, Collectors Forum, and the Modern Art Council, 92.426

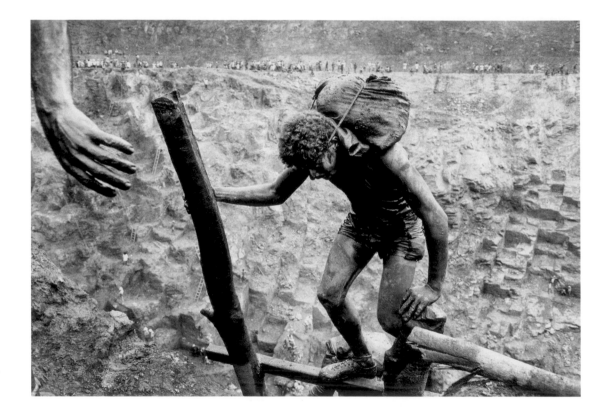

Plate 70

SEBASTIÃO SALGADO
Brazilian, born 1944

Untitled (Serra Pelada, Brazil), 1990
gelatin silver print, 20 x 16 (50.8 x 40.6)

Accessions Committee Fund: gift of Shirley Ross Davis, Susan and Robert
Green, Mary W. Thacher, and Mr. and Mrs. Brooks Walker, Jr., 90.273

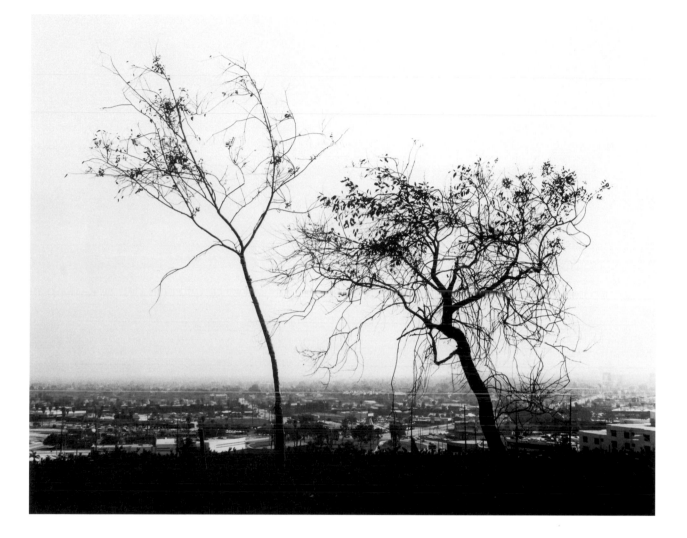

Plate 71

ROBERT ADAMS
American, born 1938

On Signal Hill Overlooking Long Beach, California, 1983
gelatin silver print, 16 x 19⅞ (40.6 x 50.5)

Accessions Committee Fund, 93.387

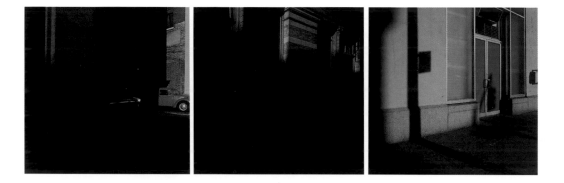

Plate 72

JAN GROOVER
American, born 1943

Untitled, 1976
chromogenic development print, 7 x 21 (17.8 x 53.3)

Gift of Carla Emil and Rich Silverstein, 96.653

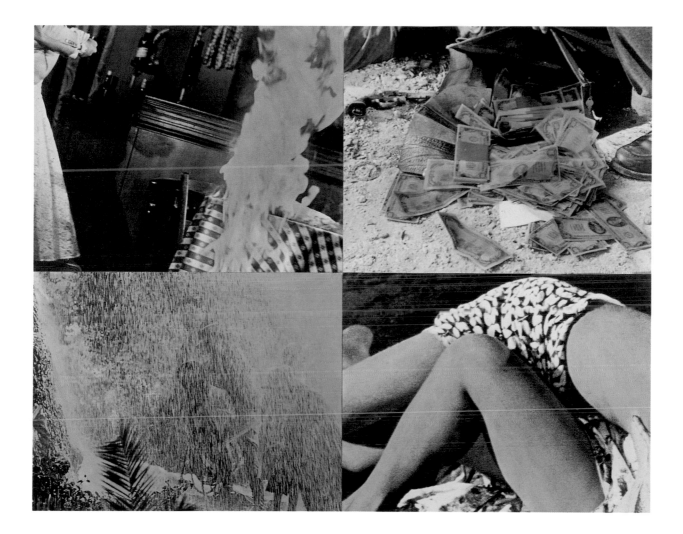

Plate 73

JOHN BALDESSARI
American, born 1931

Fire, Money, Water, Sex, 1984
oil paint on gelatin silver prints,
37¾ x 47¾ (95.9 x 121.3)

Fund of the 80s Purchase, 85.111.a–d

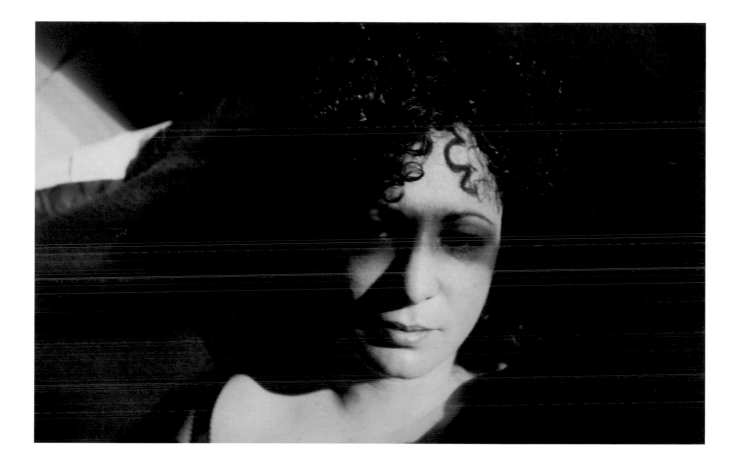

Plate 74

NAN GOLDIN
American, born 1953

Self-Portrait with Eyes Turned Inward, Boston, 1989
dye destruction print, 15¼ x 23½ (38.7 x 59.7)

Gift of Olivier Renaud-Clement on the occasion of the opening
of SFMOMA for Nan Goldin in memory of Gilles Dusein, 95.130

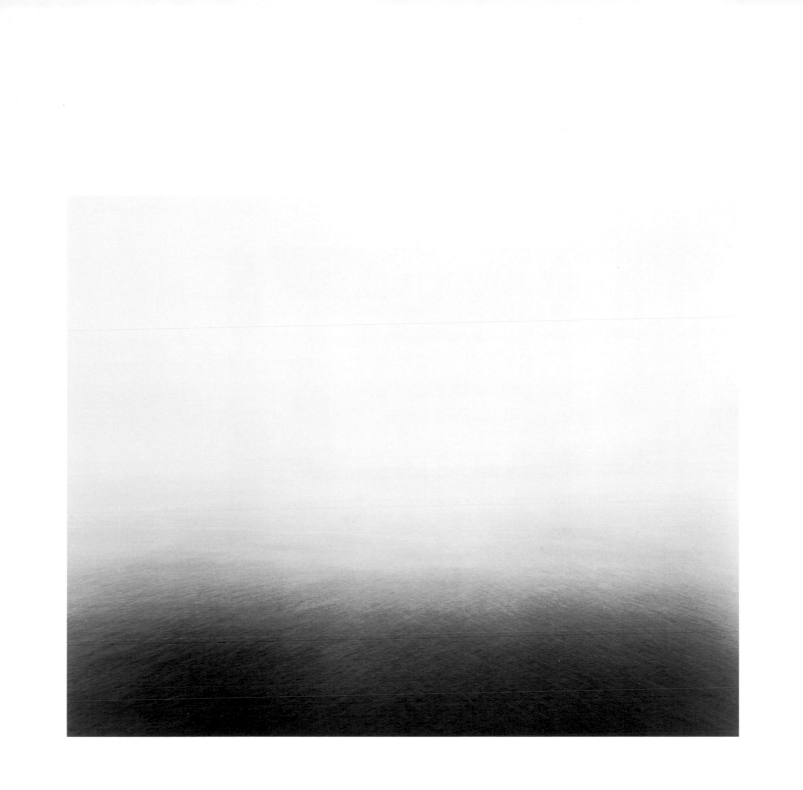

Plate 75

HIROSHI SUGIMOTO
Japanese, born 1948

Sea of Japan, Oki, 1987
gelatin silver print, 19 x 23¾ (48.3 x 60.3)

Purchased through a gift of Mimi and Peter Haas, 92.244

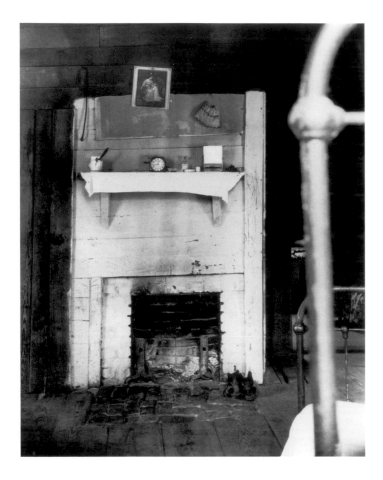

Plate 76

SHERRIE LEVINE
American, born 1947

After Walker Evans, 1991
gelatin silver print, 9 3/8 x 7 1/2 (23.8 x 19.1)

Accessions Committee Fund: gift of Evelyn and Walter Haas, Jr., Mr. and
Mrs. Donald G. Fisher, Mrs. George Roberts, and Helen and Charles
Schwab, 91.68

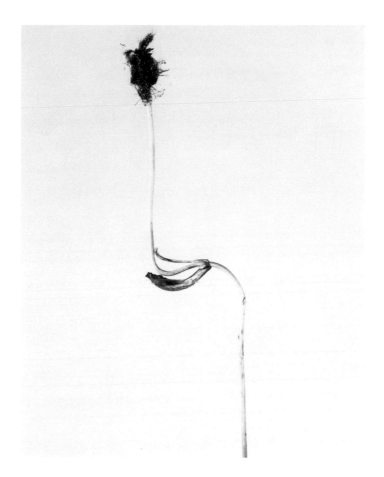

Plate *77*

JOAN FONTCUBERTA
Spanish, born 1955

Cascallus Ferragasus, 1984
gelatin silver print, 10½ x 8½ (26.7 x 21.6)

Purchased through a gift of an anonymous donor, 93.94

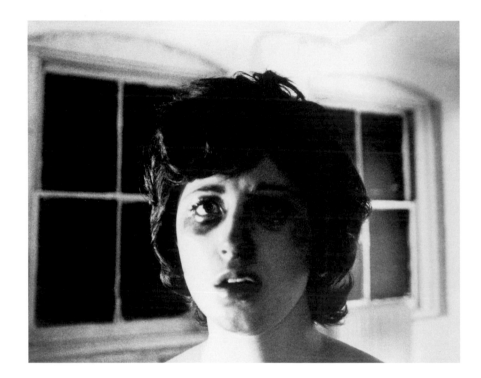

Plate 78

CINDY SHERMAN
American, born 1954

Untitled Film Still #30, 1979
gelatin silver print, 30 x 40 (76.2 x 101.6)

Accessions Committee Fund: gift of Barbara Bass Bakar,
Pam and Dick Kramlich, Norah and Norman Stone,
Mrs. Paul L. Wattis, and Collectors Forum, 92.119

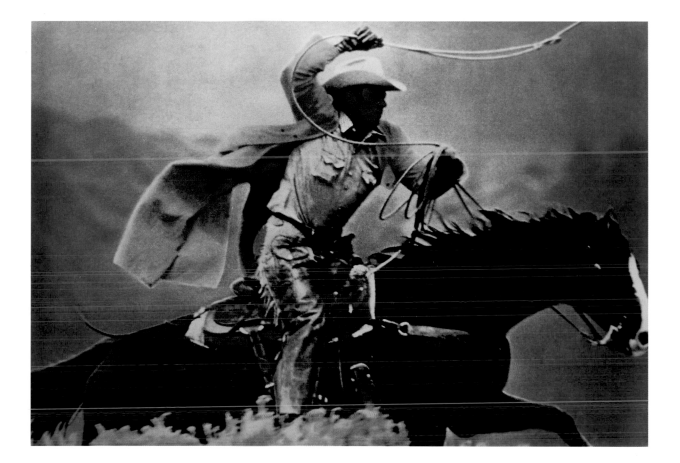

Plate 79

RICHARD PRINCE
American, born 1949

Untitled (Cowboy), 1991–92
chromogenic development print, 49 x 70 (124.5 x 177.8)

Accessions Committee Fund: gift of Jean Douglas, Doris and Donald
G. Fisher, Elaine McKeon, Byron R. Meyer, and Helen and Charles
Schwab, 92.45